# AMERICAN IMPRES

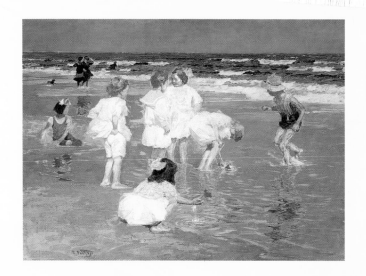

FAWCETT COLUMBINE · NEW YORK

A Fawcett Columbine Book
Published by Ballantine Books

First published in Great Britain in 1991 by
PAVILION BOOKS LIMITED
196 Shaftesbury Avenue, London WC2H 8JL

Text copyright © Pavilion Books 1991
Illustrations – Copyright and sources as indicated
on the back of each card

Cover design by Richard Aquan

ISBN: 0-449-90585-3

Printed and bound in Singapore by Imago Publishing Limited
First American Edition: October 1991

10   9   8   7   6   5   4   3   2   1

# FOREWORD

*M*any American Impressionists of the late nineteenth century initially studied art in France, where they came into contact with the French Impressionist Movement. As a result, they increasingly rejected the current dark and more literal style of American painting in favor of a more informal approach, using brighter colors and looser, more expressive brushwork. While all the artists agreed on the fundamental importance of light, they each developed very different, individual styles.

Closest to the French Impressionists was Mary Cassatt, who settled in Paris in 1868 and, under the influence of Degas, produced tender mother-and-child studies as seen in *After the Bath*, and other serene domestic scenes. A more independent expatriate figure who moved to Paris in the 1870s, John Singer Sargent typified American Impressionism. His *Paul Helleu Sketching with his Wife*, a timeless Impressionist idyll, shows not only his complete mastery of the Movement's techniques, but also the influence of his friend Monet.

Childe Hassam, J. H. Twachtman, Edmund Tarbell, Frank Benson and William M. Chase were all members of 'The American Ten', a group founded in 1898 to represent Impressionism in America. Theodore Robinson, another influential figure, painted with Monet at Giverny. His *Willows* shows a brilliant use of broken color to convey the effects of light and shadow.

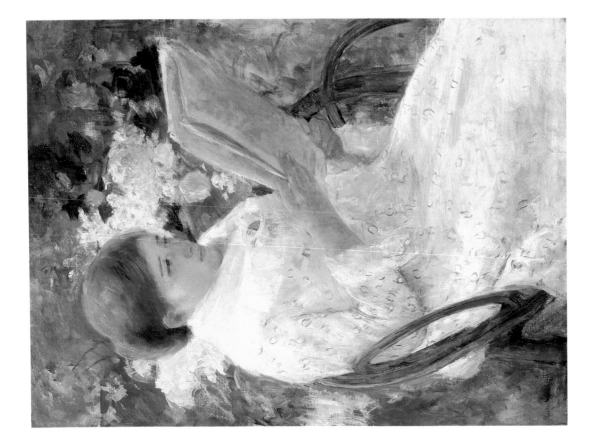

MARY CASSATT (1844-1926)
*Woman Reading in a Garden*
GIFT OF MRS ALBERT J. BEVERIDGE IN MEMORY OF HER AUNT,
DELIA SPENCER FIELD, © 1991 THE ART INSTITUTE OF CHICAGO

FAWCETT COLUMBINE, NEW YORK

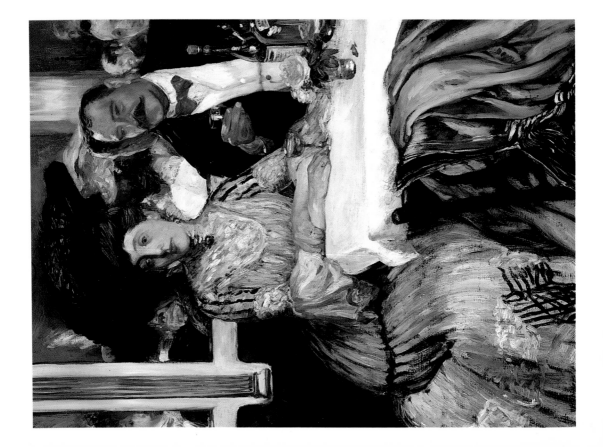

William J. Glackens (1870-1938)
*Chez Mouquin*
FRIENDS OF AMERICAN ART, © 1991 THE ART INSTITUTE OF CHICAGO

FAWCETT COLUMBINE · NEW YORK

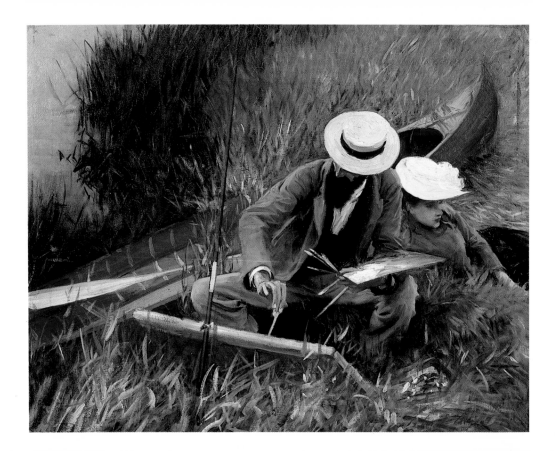

FAWCETT COLUMBINE · NEW YORK

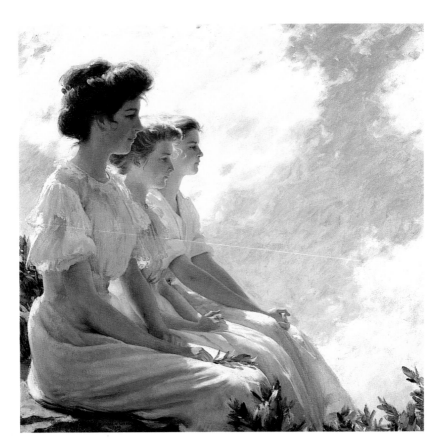

CHARLES C. CURRAN (1861-1942)
*On the Heights*
THE BROOKLYN MUSEUM/GIFT OF GEORGE D. PRATT

FAWCETT COLUMBINE · NEW YORK

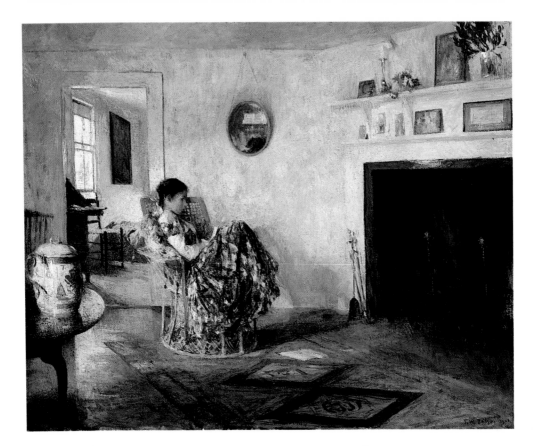

FAWCETT COLUMBINE · NEW YORK

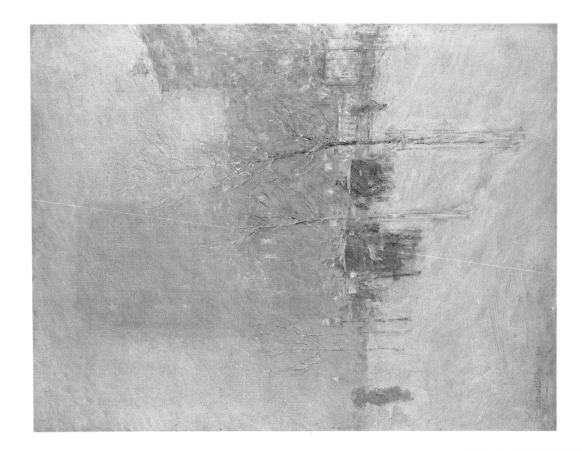

CHILDE HASSAM (1859-1935)
*Late Afternoon, New York: Winter*
THE BROOKLYN MUSEUM/DICK S. RAMSAY FUND

FAWCETT COLUMBINE · NEW YORK

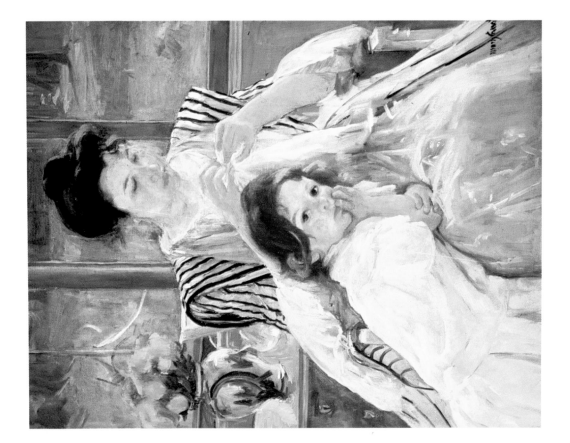

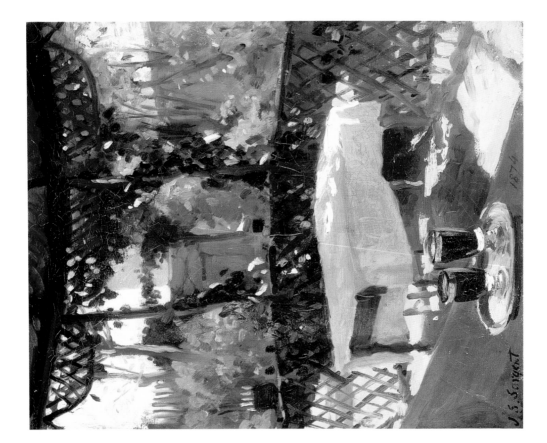

FAWCETT COLUMBINE · NEW YORK

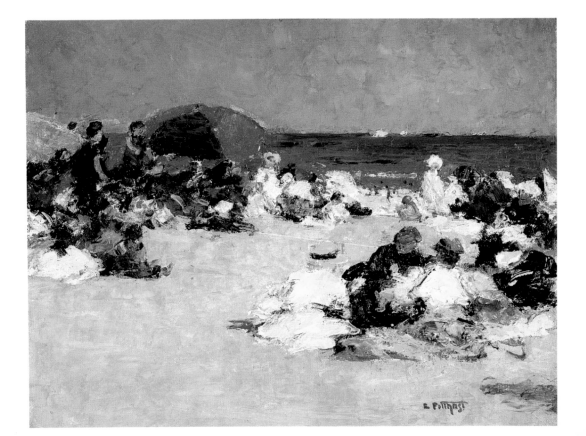

FAWCETT COLUMBINE · NEW YORK

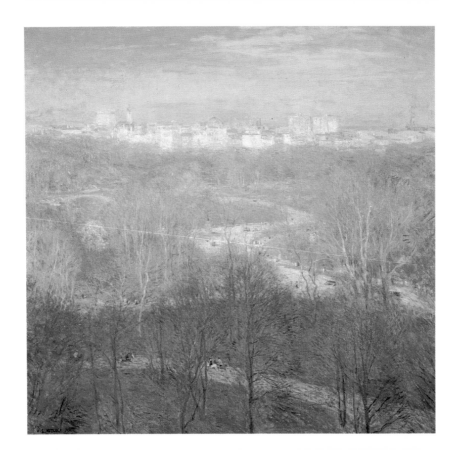

WILLARD LEROY METCALF (1858-1925)
*Early Spring Afternoon – Central Park*
THE BROOKLYN MUSEUM/FRANK L. BABBOTT FUND/
PHOTOGRAPHY: PHILIP POCOCK

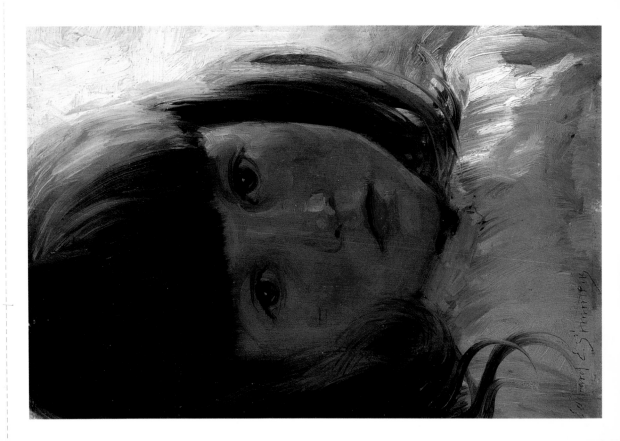

FAWCETT COLUMBINE · NEW YORK

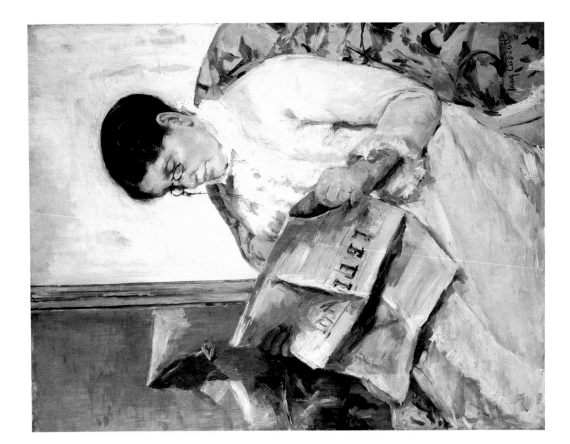

MARY CASSATT (1844-1926)
*Reading Le Figaro*
CHRISTIE'S, LONDON/BRIDGEMAN ART LIBRARY, LONDON

FAWCETT COLUMBINE · NEW YORK

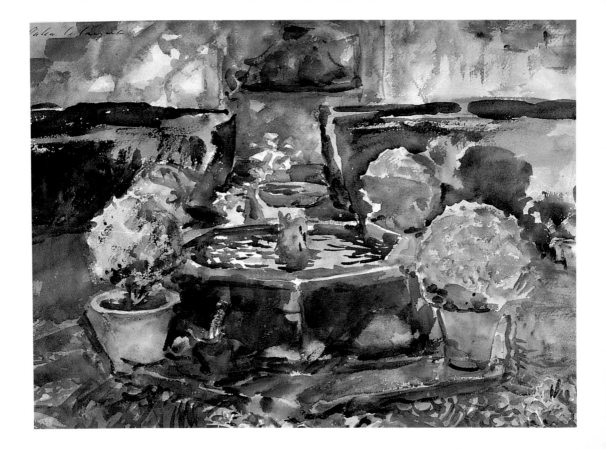

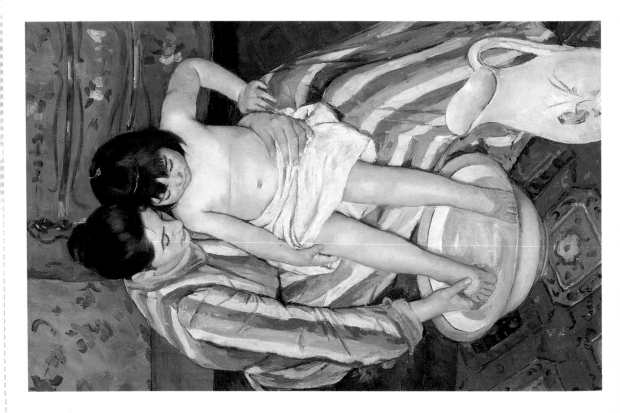

M A R Y  C A S S A T T  (1844-1926)
*The Bath*
ROBERT WALLER FUND, © 1991 THE ART INSTITUTE OF CHICAGO

F A W C E T T  C O L U M B I N E · N E W  Y O R K

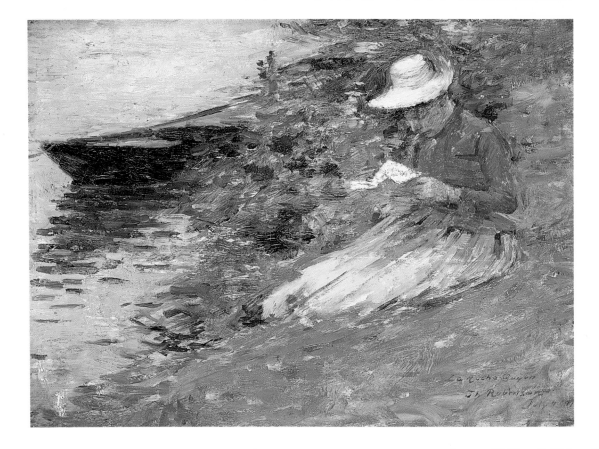

THEODORE ROBINSON (1852-1896)
*La Roche Guyon*
THE BROOKLYN MUSEUM/BEQUEST OF MRS WILLIAM A. PUTNAM

FAWCETT COLUMBINE · NEW YORK

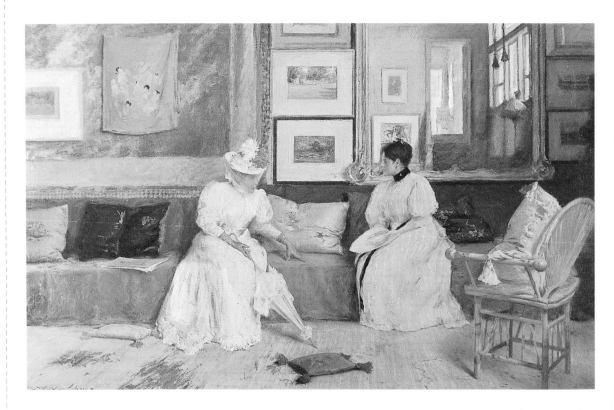

WILLIAM MERRIT CHASE (1849-1916)
*A Friendly Visit*
NATIONAL GALLERY OF ART, WASHINGTON D.C./
BRIDGEMAN ART LIBRARY, LONDON

FAWCETT COLUMBINE · NEW YORK

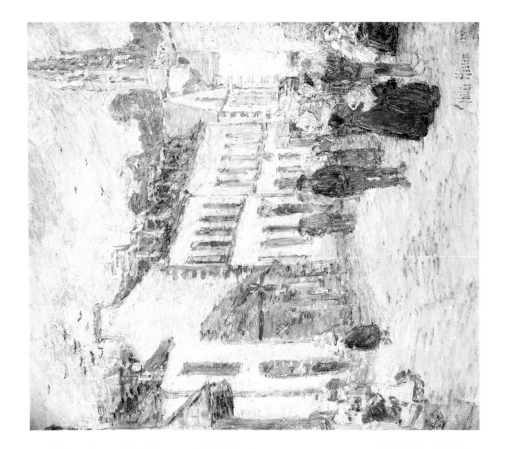

CHILDE HASSAM (1859-1935)
*An Evening Street Scene, Pont Aven*
PRIVATE COLLECTION/BRIDGEMAN ART LIBRARY, LONDON

FAWCETT COLUMBINE · NEW YORK

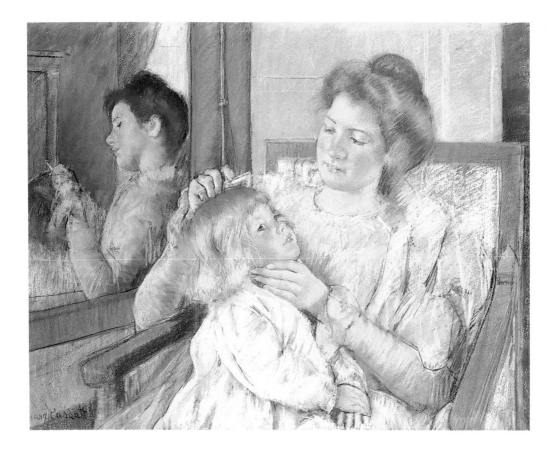

MARY CASSATT (1844-1926)
*Mother Combing her Child's Hair*
THE BROOKLYN MUSEUM/BEQUEST OF MARY T. COCKCROFT

FAWCETT COLUMBINE · NEW YORK

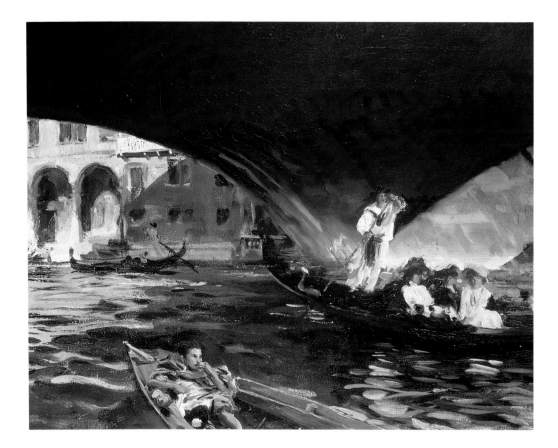

JOHN SINGER SARGENT (1856-1925)
*The Rialto, Venice*
PRIVATE COLLECTION/BRIDGEMAN ART LIBRARY, LONDON

FAWCETT COLUMBINE · NEW YORK

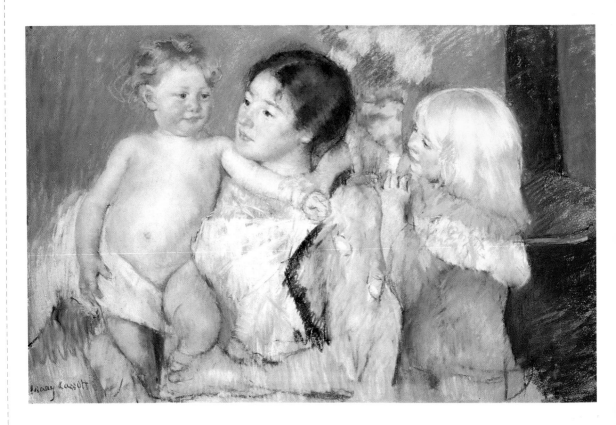

MARY CASSATT (1844-1926)
*After the Bath*
THE CLEVELAND MUSEUM OF ART/GIFT FROM J. H. WADE

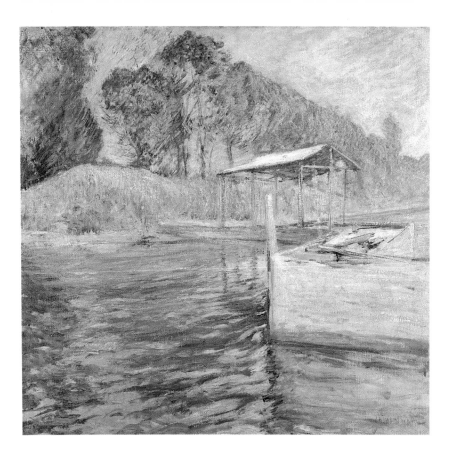

JOHN HENRY TWACHTMAN (1853-1902)
*Reflections*
THE BROOKLYN MUSEUM/DICK S. RAMSAY FUND

FAWCETT COLUMBINE · NEW YORK

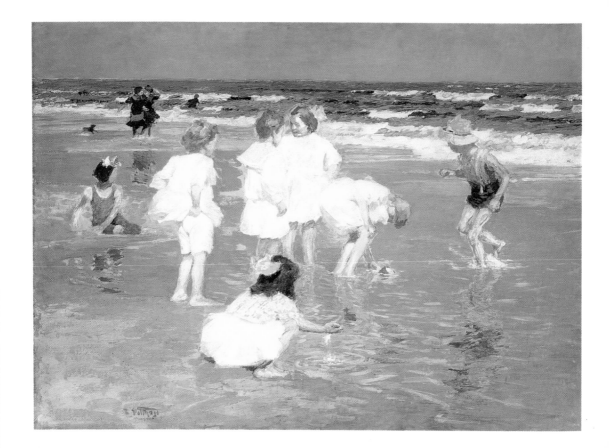

Edward H. Potthast (1857-1927)
*A Holiday*
FRIENDS OF AMERICAN ART, © 1991 THE ART INSTITUTE OF CHICAGO

FAWCETT COLUMBINE · NEW YORK

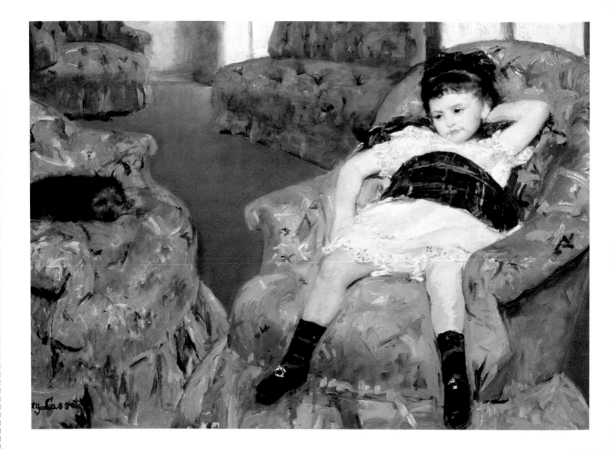

MARY CASSATT (1844–1926)
*Little Girl in a Blue Armchair*
MELLON COLLECTION, NATIONAL GALLERY OF ART, WASHINGTON D.C./
BRIDGEMAN ART LIBRARY, LONDON

FAWCETT COLUMBINE · NEW YORK

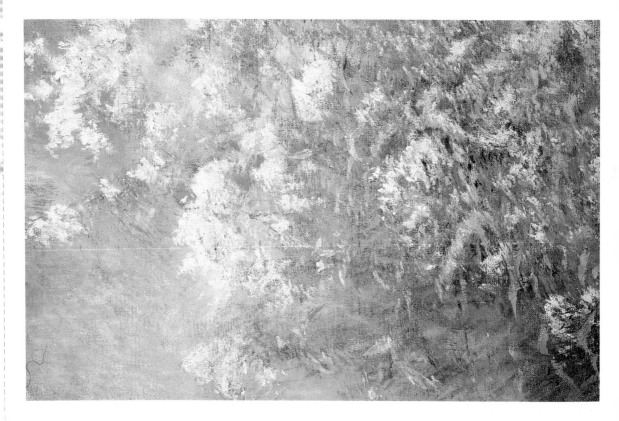

JOHN HENRY TWACHTMAN (1853-1902)
*Meadow Flowers*
THE BROOKLYN MUSEUM/POLHEMUS FUND

FAWCETT COLUMBINE · NEW YORK

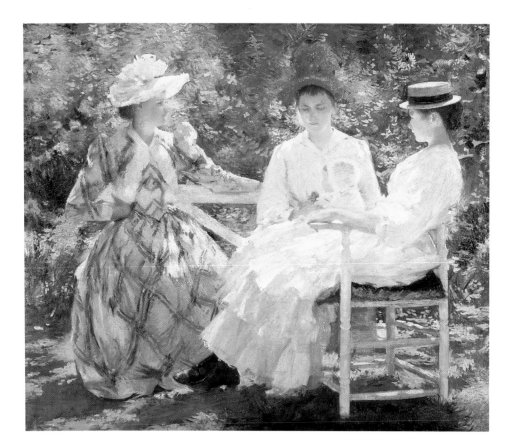

EDMUND CHARLES TARBELL (1862-1938)
*Three Sisters – A Study in June Sunlight*
MILWAUKEE ART CENTER, WISCONSIN/
BRIDGEMAN ART LIBRARY, LONDON

FAWCETT COLUMBINE · NEW YORK

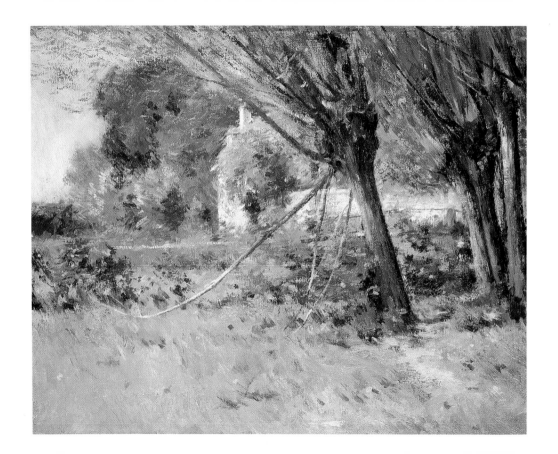

THEODORE ROBINSON (1852-1896)
*Willows (En Picardie)*
THE BROOKLYN MUSEUM/GIFT OF GEORGE D. PRATT

FAWCETT COLUMBINE · NEW YORK

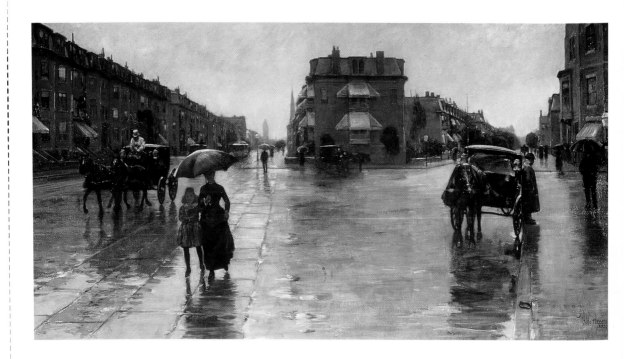

FAWCETT COLUMBINE · NEW YORK

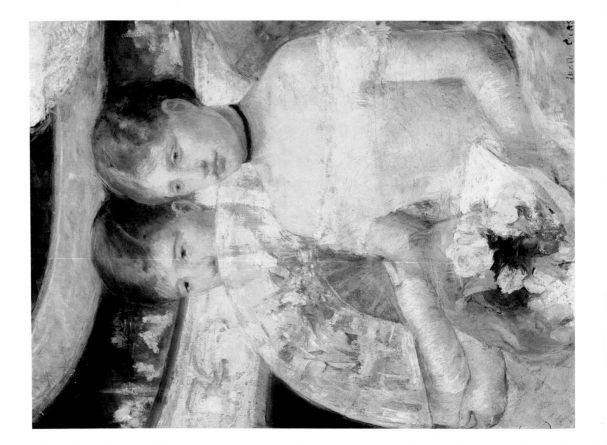

MARY CASSATT (1844-1926)
*The Theatre Box*
NATIONAL GALLERY OF ART, WASHINGTON D.C./
BRIDGEMAN ART LIBRARY, LONDON

FAWCETT COLUMBINE · NEW YORK

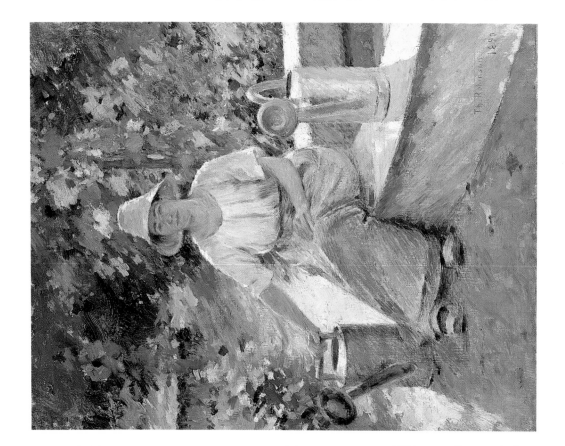

FAWCETT COLUMBINE · NEW YORK